Table of Contents

Introduction	3
Making Music Lessons Fun	5
Chapter 1 - General Group Games	11
Chapter 2 - Team Games & Activities	31
Chapter 3 - General Solo & Theory Games	45
Chapter 4 - Fretted Instrument Games	77
Chapter 5 - Piano Games	95
Chapter 6 - Vocal Games	107
Chapter 7 - Orchestral String Games	119
Chapter 8 - Drum Games	131
About the Author	143
Giving Credit Where It is Due	145
Testimonials	146

Introduction

This book was written to help music teachers to have a resource for games and other fun suggestions, so the students can feel like they are having more fun in music lessons.

Making Music Lessons Fun

Note: Some of these suggestions are better suited for group lessons, and some for one-on-one.

Making music lessons more fun for children involves incorporating a variety of engaging activities, creating a positive learning environment, and tailoring lessons to the individual interests and needs of each child. Here are some effective strategies:

1. Incorporate Games, Activities, and Challenges
- Use musical games
- Include interactive activities
- Set goals that the children can achieve with a reward if they achieve it (such as a small candy). You can use stickers to mark progress, and place it on their sheet music or lesson plans.

2. Use Visual Aids and Props
- Utilize colourful flashcards, stickers, and visual aids to teach musical notes, rhythms, and symbols.
- Introduce props like puppets or storybooks to make learning concepts more relatable and enjoyable.
- Have a white board that you can relate certain concepts in ways they will understand, such as using a half pizza to demonstrate a half step/semitone.

3. Integrate Technology
- Use apps and software designed for music education that offer interactive lessons and games, such as Yousician or Simply Piano
- Incorporate tools like digital metronomes, tuners, and backing tracks to make practice sessions more engaging.
- Record the child's playing and let them listen back. This can be both fun and educational as they hear their own progress.

4. Encourage Creativity
- Allow children to improvise and compose their own music. This fosters creativity and a deeper connection to the instrument.

- Use storytelling and have children create soundtracks for their stories using their instruments.
- Allow the child to create their own melodies or rhythms. Encourage them to experiment with different sounds and patterns.

5. Provide Positive Reinforcement
- Give plenty of encouragement and praise to build confidence and motivate students.
- Use a reward system with small incentives for reaching milestones or practicing regularly.

6. Include Movement and Physical Activity
- Integrate movement into lessons, such as dancing to rhythms or marching in time to music.
- Use body percussion (clapping, stomping) to teach rhythmic concepts.
- Have the child march or step to the beat while playing to internalize rhythm.

7. Make Lessons Social
- Pair children for duets or small group activities to build a sense of camaraderie and teamwork.
- Organize recitals or informal performances where children can showcase their progress and support each other.
- Record a video of the child playing and send it to their family. It gives them a sense of achievement and motivates them to practice.

8. Tailor Lessons to Interests
- Find out what types of music the children enjoy and incorporate those styles into lessons.
- Allow children to choose some of the pieces they learn to keep them motivated and interested.
- Create lessons around themes the child enjoys, such as holidays, favorite animals, or hobbies.

9. Use Storytelling and Themes
- Create themed lessons around holidays, seasons, or popular stories to make learning more relatable and fun.

- Use music to tell stories, and have children act out parts of the story through their instruments.

10. Keep Lessons Short and Varied
- Break up lessons into shorter segments with a variety of activities to maintain the child's attention and interest.
- Alternate between different types of activities, such as playing, listening, and moving.
- Allow short breaks if the child seems restless. Use this time for quick, fun activities like a music-related riddle or joke
- Let the kids draw something quick on a whiteboard when they are losing concentration

By combining these strategies, you can create a dynamic and enjoyable learning environment that fosters a lifelong love of music in children.

Chapter 1
General Group Games

1 - Musical Statues

A. Objective
To develop listening skills and timing.

B. Needed to Play
Music player, lively music/an instrumentalist playing.

C. How to Play
Choose a lively piece of music that the kids enjoy. Have them dance or move freely around the room while the music plays. When the music stops, they must freeze in whatever position they are in, like statues. Anyone who moves is out of that round. You can make it non-competitive by letting everyone stay in but giving points for those who stay still. Restart the music and repeat. Vary the length of time between stopping the music to keep it unpredictable.

D. Variations
Use different genres or tempos of music to challenge them in different ways.

2 - Rhythm Relay

A. Objective
To improve rhythm and coordination.

B. Needed to Play
Clapping hands or simple percussion instruments (e.g., tambourines, drumsticks, shakers).

C. How to Play
Start with simple rhythms using clapping, tapping on a table, or playing on an instrument. Clap or play a short rhythm and have the kids repeat it back to you. Increase the complexity of the rhythms as they get more comfortable. For added challenge, pass a rhythm around a circle, with each child adding their own twist before passing it on.

D. Variations
Use different body parts (e.g., stomping feet, snapping fingers) or objects (e.g., drumsticks, shakers) to create rhythms.

3 - Musical Chairs

A. Objective
To encourage quick thinking and listening.

B. Needed to Play
Chairs, music player or instrumentalist, music.

C. How to Play
Arrange chairs in a circle with one fewer than the number of participants. Play music and have the kids walk around the chairs. When the music stops, they must quickly find a chair to sit in. The child left standing is out, and one chair is removed. Continue until one child remains.

D. Variations
Play different styles of music to keep the game interesting or use different themes like holiday music or movie soundtracks.

4 - Instrument Bingo

A. Objective
To teach kids to recognize different instrument sounds.

B. Needed to Play
Bingo cards with instrument pictures, sound clips of various instruments, music player.

C. How to Play
Create bingo cards with images of various instruments. Prepare sound clips of these instruments being played. Play a sound clip and have the kids identify the instrument and mark it on their bingo card. The first child to get a line (horizontally, vertically, or diagonally) calls out "Bingo!" and wins a small prize.

D. Variations
Use different themes like orchestra instruments, world instruments, rock band instruments or others.

5 - Sound Scavenger Hunt

A. Objective
To develop listening skills and sound identification.

B. Needed to Play
Small instruments or objects that make distinct sounds, music player or sound-making device.

C. How to Play
Hide small instruments or objects that make distinct sounds around the room. Gather the kids and play a sound from one of the hidden objects. The kids must then search the room to find the object making that sound. Once found, hide it again and play a different sound.

D. Variations
Use recordings of sounds if you don't have physical objects or create a scavenger hunt with clues related to the sounds.

6 - Pass the Parcel

A. Objective
To encourage teamwork and patience.

B. Needed to Play
Small prize, wrapping paper, music player, music.

C. How to Play
Prepare a small prize wrapped in multiple layers of paper. Have the kids sit in a circle and play music while they pass the parcel around. When the music stops, the child holding the parcel removes one layer of wrapping. Continue until the last layer is removed, and the prize is revealed.

D. Variations
Include a small challenge or question in each layer that the child must complete or answer before passing the parcel.

7 - Name that Tune

A. Objective
To enhance listening skills and musical memory.

B. Needed to Play
Instrument or music player, list of familiar songs.

C. How to Play
Play a few notes of a well-known song on an instrument or from a recording. Have the kids guess the name of the tune. Start with easy, recognizable songs and gradually make them more challenging.

D. Variations
Use different genres or themes, such as Disney songs, kids' songs, popular songs, or classical music.

8 - Instrument Freeze Dance

A. Objective
To combine movement with instrument playing.

B. Needed to Play
Small instruments (e.g., tambourines, maracas, drums, ukuleles), music player, music.

C. How to Play
Give each child a small instrument like a tambourine, maraca, or drum. Play music and have the kids dance while playing their instruments. When the music stops, they must freeze and stop playing their instrument. Anyone who moves or makes a sound is out of that round.

D. Variations
Use different tempos and styles of music to challenge the kids or have them switch instruments periodically.

9 - Music Matching Game

A. Objective
To develop memory and recognition skills.

B. Needed to Play
Cards with pictures of different pairs of instruments, musical notes, time signatures, or other theory items, table or flat surface.

C. How to Play
Create pairs of cards with pictures. Place the cards face down in a grid pattern. Have the kids take turns flipping two cards at a time to find matching pairs. If they find a match, they keep the cards and take another turn. If not, they flip the cards back over and the next child goes.

D. Variations
Use sounds instead of pictures where they have to match the instrument sound to the correct card or theme the cards around composers or genres.

10 - Musical Storytelling

A. Objective
To encourage creativity and understanding of musical expression.

B. Needed to Play
Various instruments or sound-making objects.

C. How to Play
Tell a simple story and use instruments or sounds to represent different characters or actions. For example, use a drum to represent footsteps, a triangle for a magical moment, or a flute/recorder for a bird singing. Have the kids join in by adding their own sounds to the story using various instruments or sound-making objects.

D. Variations
Let the kids create their own stories and choose the sounds or have them act out the story with movements and sounds.

11 - Instrument Pass

A. Objective
To enhance instrument familiarity and sharing.

B. Needed to Play
Various small instruments (e.g., maracas, tambourines).

C. How to Play
Sit in a circle and pass the instrument around while music plays. When the music stops, the child holding the instrument must play a short rhythm or melody.

D. Variations
Use different instruments each round to expose children to various sounds. Have the children describe the instrument's sound before passing it.

12 - Echo Game

A. Objective
To improve listening and repetition skills.

B. Needed to Play
Voices or simple instruments.

C. How to Play
The teacher or leader plays or sings a short musical phrase, and the children echo it back. Start with simple phrases and gradually increase the complexity.

D. Variations
Use different dynamics (loud/soft) and tempos to challenge the children. Also use rhythmic sounds, like "ta, ti, etc." or scale sounds like "Do, Re, Mi, etc." Allow children to take turns being the leader.

13 - Music Detective

A. Objective
To enhance listening skills and attention to detail.

B. Needed to Play
Music player, a variety of songs or musical pieces.

C. How to Play
Play a piece of music and ask the children to listen carefully. Ask questions about the music afterward, such as identifying instruments, the mood of the piece, or changes in dynamics.

D. Variations
Focus on specific elements each round, like rhythm, melody, or harmony. Play excerpts from different genres to broaden their musical experience.

14 - Musical Hot Potato

A. Objective
To improve quick thinking and listening skills.

B. Needed to Play
Small soft ball, music player.

C. How to Play
Children sit in a circle and pass the "hot potato" (ball) around while music plays. When the music stops, the child holding the ball must perform a musical task, like singing a line from a song or clapping a rhythm.

D. Variations
Use different musical tasks each round. Change the direction of passing to keep it unpredictable.

15 - Beat the Drum

A. Objective
To develop rhythm and coordination.

B. Needed to Play
Drum or any percussion instrument.

C. How to Play
One child plays a simple rhythm on the drum, and the others must mimic it. Gradually increase the complexity of the rhythms.

D. Variations
Use different percussion instruments each round. Have children create their own rhythms for others to mimic.

16 - Melody Matching

A. Objective
To enhance pitch recognition and memory.

B. Needed to Play
Music player, a set of simple melodies.

C. How to Play
Play a short melody and have the children match it by singing or playing it back on an instrument.

D. Variations
Increase the complexity of the melodies as children improve. Use different instruments for variety. Also, play a melody on one instrument/in one key, then play four separate melodies on another instrument/in another key that are similar, but only one is the correct match to the one played on the first instrument/key (using the same intervals).

17 - Musical Dice

A. Objective
To encourage creative expression and musical interpretation.

B. Needed to Play
Variety of instruments, story prompts.

C. How to Play
Tell a story and have children use instruments to create sound effects and musical accompaniments for different parts of the story.

D. Variations
Allow children to create their own stories and soundscapes. Use different themes, such as fairy tales or adventures, to inspire creativity.

18 - Melody Match-Up

A. Objective
To enhance listening skills, musical memory, and cooperation.

B. Needed to Play
Music player, several short melodies or song excerpts, index cards.

C. How to Play
Before the game, prepare pairs of index cards with the names or symbols of different short melodies or song excerpts. Shuffle and distribute these cards to the children. Play one of the melodies or excerpts. The children must then find their match by finding the other person who has the same melody on their card. Once they find their match, they both sit down together.

D. Variations
Use more complex or longer melodies as the children get better at the game. Include instrumental sounds and have the children identify which instrument is playing before finding their match. Make it a timed challenge where the children must find their match within a certain amount of time.

Chapter 2
Team Games & Activities

1 - Musical Charades

A. Objective
To develop creativity and teamwork.

B. Needed to Play
Slips of paper with song titles or musical actions.

C. How to Play
Divide children into teams. One member of each team draws a slip and acts out the song, musical action without speaking, or sings/plays the melody of the song while their team guesses.

D. Variations
Use different categories like musical instruments, famous musicians, or musical genres.

2 - Rhythm Relay Race

A. Objective
To improve rhythm recognition and coordination.

B. Needed to Play
Rhythm instruments (e.g., drums, tambourines)/hands, metronome.

C. How to Play
Divide children into teams. One team member starts by playing a rhythm on an instrument or clapping, and the next team member must repeat it and add their own. Continue down the line, with each child adding to the rhythm.

D. Variations
Increase the complexity of the rhythms. Incorporate other body percussion - slapping, snapping, stomping, etc., or beats made with mouth sounds.

3 - Musical Memory Match

A. Objective
To enhance memory and musical knowledge.

B. Needed to Play
Cards with pictures of instruments, musicians, or musical notes.

C. How to Play
Divide children into teams. Spread the cards face down. Team members take turns flipping two cards to find matches. The team with the most matches wins.

D. Variations
Use sounds instead of pictures, where the children have to match the sound with the instrument.

4 - Compose a Song

A. Objective
To encourage creativity and collaboration.

B. Needed to Play
Instruments, paper, and pencils.

C. How to Play
Divide children into teams. Each team writes and composes a short song, then performs it for the group.

D. Variations
Assign specific themes or genres. Include a challenge like incorporating specific words or instruments.

5 - Musical Jeopardy

A. Objective
To test and expand musical knowledge.

B. Needed to Play
Jeopardy board with categories and questions related to music.

C. How to Play
Divide children into teams. Teams take turns choosing a category and answering questions to earn points. The team with the most points wins.

D. Variations
Include audio or video clips in the questions. Use different levels of difficulty for mixed-age groups.

6 - Beat the Clock

A. Objective
To improve quick thinking and musical skills.

B. Needed to Play
Timer, a list of musical tasks (e.g., play a C chord, clap a rhythm).

C. How to Play
Divide children into teams. Each team must complete as many musical tasks as possible within a set time. The team that completes the most tasks wins.

D. Variations
Use a theme for the tasks, like holiday songs or classical music. Incorporate different instruments or vocal tasks.

7 - Musical Scavenger Hunt

A. Objective
To develop listening skills and teamwork.

B. Needed to Play
List of musical items or sounds to find (e.g., a song with a piano solo, a drum set).

C. How to Play
Divide children into teams. Teams must find and collect items or identify sounds on the list within a set time. The team that finds the most items wins.

D. Variations
Use different themes, like musical genres or instruments. Incorporate physical objects and sounds.

8 - Soundtrack Creation

A. Objective
To encourage creativity and teamwork.

B. Needed to Play
Instruments, a short video clip or story.

C. How to Play
Divide children into teams. Each team creates a soundtrack for the video clip or story, then presents it to the group.

D. Variations
Use different types of video clips, like animations or nature scenes. Include specific musical elements, like a crescendo or a specific rhythm.

9 - Group Conducting

A. Objective
To develop leadership and musical interpretation skills.

B. Needed to Play
Instruments, conducting baton or pointer.

C. How to Play
Divide children into teams. Each team member takes turns being the conductor, leading their team in playing a piece of music with different dynamics, tempos, and expressions.

D. Variations
Use different pieces of music for each round. Include challenges like playing in a specific style or using certain instruments.

10 - Musical Puzzle Race

A. Objective
To improve musical theory knowledge and teamwork.

B. Needed to Play
Large puzzle pieces with musical notes or symbols.

C. How to Play
Divide children into teams. Teams race to assemble the puzzle correctly, identifying and placing the musical notes or symbols in the right order.

D. Variations
Use different types of puzzles, like a giant staff with notes to place or chord symbols to match. Include a timed challenge for added excitement.

11 - Musical Relay

A. Objective
To improve coordination, teamwork, and musical memory.

B. Needed to Play
A selection of instruments (one for each team), a set of simple musical phrases or rhythms written on cards.

C. How to Play
Divide the children into teams. Each team lines up, and the first player runs to a designated spot, picks up a card with a musical phrase or rhythm, and plays it on their instrument. After successfully playing the phrase, they run back and tag the next team member, who repeats the process. The game continues until all team members have had a turn.

D. Variations
Use different instruments for each relay leg to introduce variety. Have the phrases increase in complexity as the game progresses. Include a memory challenge by having the team members remember and play back the previous players' phrases.

12 - Musical Obstacle Course

A. Objective
To improve coordination, teamwork, and musical skills.

B. Needed to Play
Various musical instruments, obstacle course items (cones, ropes, mats), a music player.

C. How to Play
Set up an obstacle course with different stations. Each station has a musical task (e.g., play a scale on a keyboard, tap out a rhythm on a drum, sing a short melody). Divide the children into teams. One at a time, team members must navigate the obstacle course, completing the musical tasks at each station before tagging the next teammate.

D. Variations
Change the musical tasks at each station to keep the course interesting. Use different types of music for background to set the pace or mood. Add more physical challenges to the course to increase difficulty.

Chapter 3
General Solo & Theory Games

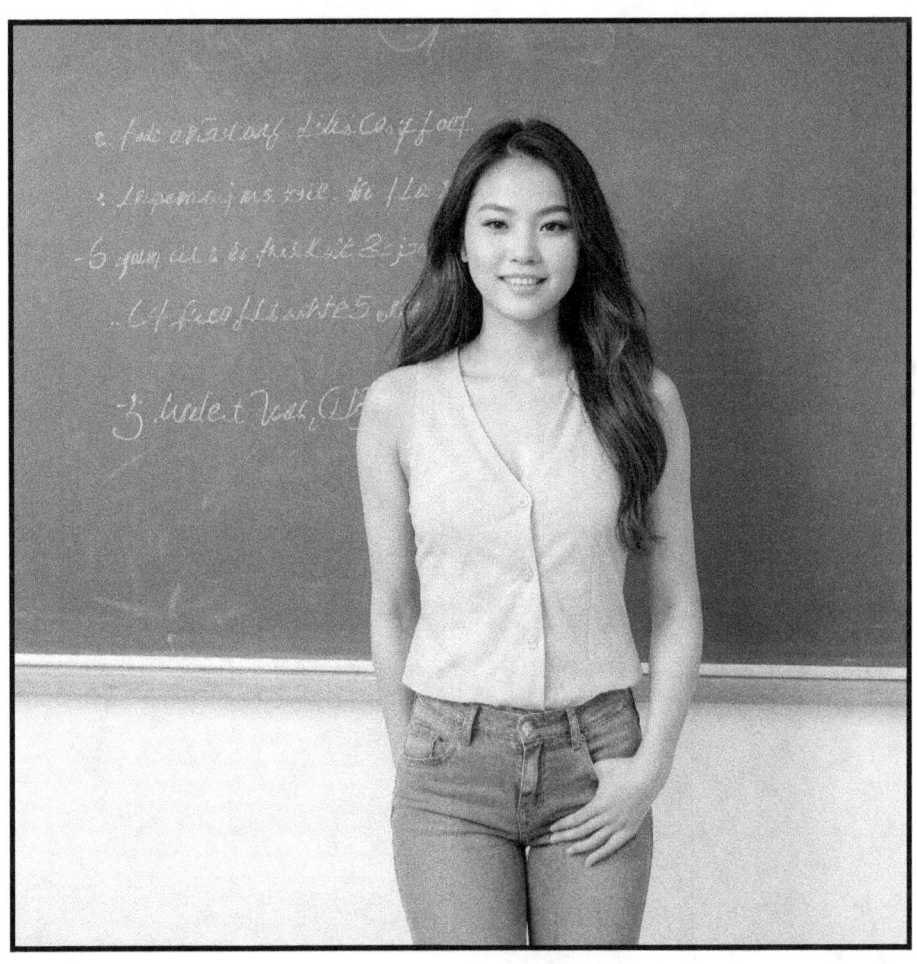

1 - Rhythm Clapback

A. Objective
To develop rhythm and timing.

B. Needed to Play
Hands/Rhythmic instrument

C. How to Play
Clap a short rhythm pattern and have the student clap it back. Gradually increase the complexity of the rhythms as they improve.

D. Variations
Use a metronome to maintain a steady beat. Incorporate different body percussion (e.g., stomping feet, patting thighs) or use rhythm instruments.

E. Skill Level
Beginner to Intermediate.

2 - Musical Flashcards

A. Objective
To help with note recognition and quick reading

B. Needed to Play
Flashcards with notes, symbols, simple melodies, or rhythms.

C. How to Play
Show a flashcard to the student and have them quickly identify and play the note, rhythm, melody, chord, or articulation on their instrument. Time how fast they can do it and encourage them to beat their previous times.

D. Variations
Use flashcards with different key signatures or intervals. Challenge the student by using rhythm flashcards that they need to clap before playing the notes.

E. Skill Level
Beginner to Intermediate.

3 - Scale Race

A. Objective
To improve scale knowledge and speed.

B. Needed to Play
A melodic instrument.

C. How to Play
Have the student play a scale as quickly and accurately as possible. Time their performance and encourage them to beat their previous times.

D. Variations
Challenge the student with different scales (major, minor, pentatonic) or play scales in contrary motion. Have them practice scales with different articulations (e.g., staccato, legato).

E. Skill Level
Beginner to Advanced.

4 - Tempo Challenge

A. Objective
To develop a sense of tempo and adaptability.

B. Needed to Play
Instrument, metronome

C. How to Play
elect a piece or section of music for the student to play. Start at a comfortable tempo and have the student play through it. Gradually increase or decrease the tempo using a metronome, challenging the student to adapt their playing speed accordingly.

D. Variations
Change the tempo abruptly to test the student's adaptability. Use different styles of music to see how well the student can maintain the character of the piece at varying speeds.

E. Skill Level
Beginner to Intermediate.

5 - Musical Simon Says

A. Objective
To improve listening skills and instrument control.

B. Needed to Play
Instrument.

C. How to Play
The teacher says "Simon says" followed by a musical instruction (e.g., play a C note, play staccato, play loudly). The student only follows the instruction if it starts with "Simon says." If the instruction does not start with "Simon says," the student should not play it.

D. Variations
Use more complex musical instructions as the student progresses, such as playing scales, specific rhythms, or dynamics. Include movements or techniques specific to the instrument (e.g., bowing techniques for string instruments).

E. Skill Level
Beginner to Intermediate.

6 - Rhythm Bingo

A. Objective
To enhance rhythm reading and performance.

B. Needed to Play
Bingo cards with different rhythmic patterns, instrument, a list of rhythms to call out.

C. How to Play
Create bingo cards with different rhythmic patterns in each square. The teacher calls out or claps a rhythm, and the student must find and play the corresponding rhythm on their bingo card. The goal is to get a line of rhythms correct.

D. Variations
Use different time signatures or include more complex rhythms as the student improves. Have the student create their own bingo cards with rhythms they find challenging.

E. Skill Level
Beginner to Intermediate.

7 - Improv Roulette

A. Objective
To encourage creativity and spontaneous playing.

B. Needed to Play
Instrument, a spinner or dice, a list of musical elements (e.g., keys, tempos, styles).

C. How to Play
Create a spinner or use dice to randomly select musical elements like key, tempo, and style. The student then has to improvise a short piece of music incorporating those elements. For example, they might have to play a fast blues in the key of G.

D. Variations
Add more elements to the spinner or dice, such as specific scales, modes, or articulations. Challenge the student by having them incorporate multiple elements into one improvisation session.

E. Skill Level
Intermediate to Advanced.

8 - Melody Match

A. Objective
To improve pitch recognition and memory.

B. Needed to Play
Instrument, a set of melody cards with simple melodies written on them.

C. How to Play
Show the student a card with a simple melody written on it. The student listens as the teacher plays the melody, then tries to find and play the matching melody on their instrument.

D. Variations
Increase the difficulty by using longer or more complex melodies. Have the student notate the melody they hear before playing it.

E. Skill Level
Beginner to Advanced

9 - Dynamics Dash

A. Objective
To develop dynamic control and expressive playing.

B. Needed to Play
Instrument, dynamic cards (e.g., piano, forte, crescendo, diminuendo).

C. How to Play
Draw a card from the dynamic deck and have the student play a piece or a section of a piece with the specified dynamic. For example, if the card says "crescendo," they should gradually increase the volume while playing.

D. Variations
Combine dynamic cards with tempo cards for more varied challenges. Use pieces with different expressive markings and have the student interpret them dynamically.

E. Skill Level
Beginner to Intermediate.

10 - Scale Scramble

A. Objective
To improve scale knowledge and finger technique.

B. Needed to Play
Instrument, cards with different scales written on them.

C. How to Play
Shuffle the scale cards and have the student draw one at random. The student must then play the scale accurately on their instrument. For added challenge, time them to see how quickly and accurately they can play the scale.

D. Variations
Include different types of scales (major, minor, pentatonic, chromatic). Have the student play the scales in different rhythms or articulations, or use a metronome to vary the tempo. Another variation is to do the scales in different arpeggio order, like 1, 3, 2, 4, 3, 5, etc.

E. Skill Level
Beginner to Intermediate.

11 - Song Structure Scramble

A. Objective
To understand and memorize song structures.

B. Needed to Play
Instrument, a list of song sections (e.g., verse, chorus, bridge).

C. How to Play
Write down the sections of a song on separate pieces of paper and mix them up. Have the student put them in the correct order and then play through the song, focusing on transitioning smoothly between sections.

D. Variations
Use different songs with varying structures. Challenge the student to create their own song structure and compose a piece based on it.

E. Skill Level
Beginner.

12 - Tempo Trainer

A. Objective
To develop timing and adaptability.

B. Needed to Play
Instrument, metronome.

C. How to Play
Choose a piece or a section of music for the student to play. Start at a comfortable tempo with the metronome and have the student play through it. Gradually increase or decrease the tempo, challenging the student to adapt their playing speed accordingly.

D. Variations
Change the tempo abruptly to test the student's adaptability. Use different styles of music to see how well the student can maintain the character of the piece at varying speeds.

E. Skill Level
Beginner to Advanced.

13 - Sight-Reading Sprint

A. Objective
To improve sight-reading skills.

B. Needed to Play
Instrument, simple sheet music or short sight-reading exercises.

C. How to Play
Provide the student with a short piece of sheet music they haven't seen before. Give them a limited amount of time to look it over, then have them play it. Gradually use more complex pieces as they improve.

D. Variations
Provide the student with a short piece of sheet music they haven't seen before. Give them a limited amount of time to look it over, then have them play it. Gradually use more complex pieces as they improve.

E. Skill Level
Beginner to Advanced.

14 - Interval Identification

A. Objective
To improve ear training and interval recognition.

B. Needed to Play
Instrument, a set of cards with intervals written on them.

C. How to Play
Shuffle the interval cards and have the student draw one. The student must then play the interval on the bass and identify it by ear.

D. Variations
Play the intervals for the student to identify by ear without looking at the card. Challenge the student to play intervals in different positions on the fretboard.

E. Skill Level
Intermediate to Advanced.

15 - Arpeggio Adventure

A. Objective
To improve arpeggio knowledge and finger technique.

B. Needed to Play
Instrument, a set of cards with different arpeggios written on them (e.g., major, minor, diminished)..

C. How to Play
Shuffle the arpeggio cards and have the student draw one at random. The student must then play the arpeggio accurately on their instrument, focusing on clean and even playing.

D. Variations
Include arpeggios of different chord types (e.g., seventh chords, augmented). Challenge the student to play the arpeggios in different positions on the fretboard. Incorporate rhythmic variations and different articulations (e.g., legato, staccato) to add complexity.

E. Skill Level
Intermediate to Advanced.

18 - Melody Matcher

A. Objective
To enhance ear training and playing by ear.

B. Needed to Play
Instrument, a set of simple melodies or riffs written on cards.

C. How to Play
Shuffle the melody cards and have the student draw one. The student must listen to the teacher play the melody or riff and then try to replicate it by ear on their guitar/bass. Start with simple melodies and increase the complexity as the student improves.

D. Variations
Use melodies from different genres to expose the student to various styles. Challenge the student to transcribe the melody they hear and then play it in a different key. Have the student create their own melodies and play them back for the teacher to match.

E. Skill Level
Beginner to Advanced.

19 - Finger Number Game

A. Objective
To help with finger strength and dexterity.

B. Needed to Play
Instrument and hands.

C. How to Play
Call out different finger numbers (1-5 for some instruments, T & 1-4 for other instruments) and have the student play notes on the instrument with the corresponding finger. Start slowly and gradually increase the speed.

D. Variations
Ask the student to play simple melodies or scales using only specific fingers. Incorporate finger exercises that involve crossing fingers over each other.

E. Skill Level
Beginner

20 - Sound Simon

A. Objective
To improve memory, listening skills, and instrument familiarity.

B. Needed to Play
Instrument, a list of short musical phrases or sequences.

C. How to Play
The teacher plays a short musical phrase or sequence on the instrument. The student listens and then tries to play the exact sequence back. Start with simple phrases and gradually increase the complexity as the student improves.

D. Variations
Use different rhythms, dynamics, and articulations to challenge the student's listening and playing abilities. Play the sequences in different keys or modes. Have the student create their own sequences for the teacher to replicate.

E. Skill Level
Beginner to Intermediate.

21 - Note Name Challenge

A. Objective
To enhance note reading skills.

B. Needed to Play
Flashcards with notes on the staff.

C. How to Play
Show a flashcard with a note, and the student must identify the note name.

D. Variations
Use both treble and bass clefs. Include ledger lines for advanced students.

E. Skill Level
Beginner to Intermediate.

22 - Chord Construction

A. Objective
To understand and construct chords.

B. Needed to Play
Flashcards with chord names, paper and pencil.

C. How to Play
Provide a chord name, and the student writes down the notes that make up the chord.

D. Variations
Use different types of chords (e.g., major, minor, diminished, augmented).

E. Skill Level
Intermediate to Advanced.

23 - Scale Spelling Bee

A. Objective
To learn the notes in various scales.

B. Needed to Play
Flashcards with scale names.

C. How to Play
Show a scale name, and the student must spell out the notes in the scale.

D. Variations
Include different types of scales (e.g., major, minor, pentatonic, blues). Also, reverse it: have cards with all the notes in order, and the student names the scale.

E. Skill Level
Beginner to Intermediate.

24 - Interval Identification

A. Objective
To identify and understand musical intervals.

B. Needed to Play
Flashcards with intervals.

C. How to Play
Show an interval on a staff, and the student must name the interval. Start with only second, third, etc. On other levels, add the "majors," "minors," "perfects," etc.

D. Variations
Play intervals on a pitch instrument for the student to identify by ear. Also go down in intervals, as well as up.

E. Skill Level
Intermediate to Advanced.

25 - Key Signature Quiz

A. Objective
To learn and identify key signatures.

B. Needed to Play
Flashcards with key signatures.

C. How to Play
Show a key signature, and the student must identify the key.

D. Variations
Include both major and minor keys. Challenge the student with more complex key signatures.

E. Skill Level
Beginner to Intermediate.

26 - Time Signature Match-Up

A. Objective
To understand and identify time signatures.

B. Needed to Play
Flashcards with time signatures and corresponding rhythmic patterns.

C. How to Play
Show a time signature, and the student matches it with a correct rhythmic pattern.

D. Variations
Use compound and irregular time signatures.

E. Skill Level
Beginner to Intermediate.

27 - Time Signature ID

A. Objective
To understand and identify time signatures.

B. Needed to Play
Instrument

C. How to Play
An instrument will play a looped melody/chord sequence, and the student guesses the time signature based on the feel.

D. Variations
Use compound and irregular time signatures

E. Skill Level
Beginner to Intermediate.

28 - Rhythmic Dictation

A. Objective
To develop rhythmic dictation skills.

B. Needed to Play
Paper and pencil, metronome.

C. How to Play
Clap or tap a rhythmic pattern, and the student writes it down.

D. Variations
Use different time signatures and more complex rhythms. Also, play different notes, telling the student what the first note is, and have them write down the note and its rhythmic value, combining interval identification and rhythm.

E. Skill Level
Intermediate to Advanced.

29 - Melody Memory

A. Objective
To enhance melodic dictation and memory.

B. Needed to Play
Paper and pencil.

C. How to Play
Play a short melody, giving only the first note and the student writes it down from memory.

D. Variations
Increase the length and complexity of the melodies.

E. Skill Level
Intermediate to Advanced.

30 - Dynamic Dice

A. Objective
To learn and apply dynamic markings.

B. Needed to Play
Dice with different dynamic markings (e.g., p, f, mf, mp).

C. How to Play
Roll the dice and have the student apply the dynamic marking to a short musical phrase.

D. Variations
Combine dynamics with articulation markings.

E. Skill Level
Beginner to Intermediate.

31 - Chord Progression Practise

A. Objective
To understand chord progressions and harmonic function.

B. Needed to Play
Flashcards with chord symbols.

C. How to Play
Show a series of chord symbols, and the student writes a possible chord progression.

D. Variations
Include different keys and types of chords (e.g., sevenths, extended chords). Also, use chord numbers and a key, and see if they can identify the correct chords with the key and chord numbers.

E. Skill Level
Intermediate to Advanced.

32 - Music terms Trivia

A. Objective
To learn and remember musical terms.

B. Needed to Play
Flashcards with musical terms and definitions.

C. How to Play
Show a musical term, and the student must give the correct definition..

D. Variations
Include more advanced terms and symbols.

E. Skill Level
Beginner to Advanced.

Chapter 4
Fretted Instrument Games

1 - Chord Challenge

A. Objective
To enhance chord recognition and playing.

B. Needed to Play
Strumming instrument (most often guitar and ukulele)

C. How to Play
Call out different chords (e.g., C, Dm) and have the student find and play them on the guitar/ukulele. You can add variations for guitar by including different bass notes (e.g. D/F♯) or for both by using extended chords (Am7, D2).

D. Variations
Use chord progressions instead of single chords. Incorporate ear training by playing a chord and having the student identify it by ear before playing it on the guitar/ukulele.

E. Skill Level
Beginner to Advanced.

2 - Improvisation Station

A. Objective
To encourage creativity and spontaneous playing.

B. Needed to Play
Guitar

C. How to Play
Set a simple chord progression or a key signature, and have the student improvise a melody over it. Encourage them to experiment with different rhythms, dynamics, styles, and types of scales (especially pentatonic and blues).

D. Variations
Use different styles of music (e.g., blues, classical, pop) or time signatures (e.g. 4/4, 6/8, etc.) for the improvisation. Have the student improvise a melody over a backing track or a simple accompaniment played by the teacher.

E. Skill Level
Intermediate to Advanced.

3 - Chord Bingo

A. Objective
To improve chord recognition and transitioning.

B. Needed to Play
Strumming instrument (most often guitar or ukulele), bingo cards with chord diagrams, a list of chords to call out.

C. How to Play
Create bingo cards with different chord diagrams in each square. The teacher calls out a chord, and the student must find and play the corresponding chord on their bingo card. The goal is to get a line of chords correct.

D. Variations
Include more complex chords like barre chords (for guitar), seventh chords, or extended chords. Have the student create their own bingo cards with chords they find challenging.

E. Skill Level
Beginner to Intermediate

4 - Strumming Patterns Memory

A. Objective
To enhance strumming pattern recognition and rhythm.

B. Needed to Play
Strumming instrument (most often guitar or ukulele), cards with different strumming patterns written or drawn.

C. How to Play
Show the student a card with a strumming pattern. Have them memorize it and then play it on the guitar/ukulele. Increase the difficulty by adding more complex patterns or combining multiple patterns in sequence.

D. Variations
Use a metronome to keep a steady tempo. Incorporate different time signatures or genres (e.g., rock, reggae) to vary the strumming styles.

E. Skill Level
Beginner to Intermediate

5 - Scale Pattern Challenge

A. Objective
To improve scale knowledge and finger dexterity.

B. Needed to Play
Fretted instrument, cards with different scales or scale patterns written on them.

C. How to Play
Shuffle the scale pattern cards and have the student draw one at random. Then have them pick from another set of cards that have root notes. The student must then play the scale pattern with the root note accurately on their fretted instrument. For added challenge, time them to see how quickly and accurately they can play the scale.

D. Variations
Include different types of scales (major, minor, pentatonic, blues). Have the student play the scales in different positions on the fretboard or with varying rhythms and articulations.

E. Skill Level
Beginner to Intermediate.

6 - Riff Repeat

A. Objective
To enhance listening skills and playing by ear.

B. Needed to Play
Fretted instrument, a selection of simple riffs, licks, or bass lines.

C. How to Play
Play a short riff or lick for the student. They must listen carefully and then try to replicate it on their fretted instrument. Start with simple riffs/bass lines and gradually increase the complexity.

D. Variations
Use riffs from different genres or famous songs. Challenge the student by incorporating bends, slides, and other techniques into the riffs.

E. Skill Level
Beginner to Advanced

7 - Finger Gymnastics

A. Objective
To improve finger strength and independence.

B. Needed to Play
Fretted instrument.

C. How to Play
Create a series of finger exercises for the student to practice, such as finger stretches, spider exercises, or finger independence drills. Have the student play these exercises slowly and accurately, gradually increasing the speed as they improve.

D. Variations
Incorporate hammer-ons, pull-offs, and other techniques into the exercises. Use different scales or arpeggios to vary the exercises.

E. Skill Level
Beginner to Intermediate

8 - Chord Construction Challenge

A. Objective
To improve chord construction and understanding of chord theory.

B. Needed to Play
Strumming instrument (most often guitar or ukulele), a set of cards with chord names or types (e.g., major, minor, seventh, diminished).

C. How to Play
Shuffle the cards and have the student draw one at random. The student must then construct and play the chord on the guitar. Encourage the student to find different voicings of the chord across the fretboard.

D. Variations
Increase the difficulty by using more complex chords, such as extended or altered chords. Have the student explain the notes that make up the chord and why they are chosen. Incorporate ear training by playing a chord and having the student identify it by ear before constructing it on the guitar.

E. Skill Level
Beginner to Intermediate

9 - Fretboard Frenzy

A. Objective
To improve fretboard knowledge and note recognition.

B. Needed to Play
Fretted instrument, a set of cards with different notes written on them.

C. How to Play
Shuffle the cards and have the student draw one at random. The student must then find and play the note on the fretted instrument as quickly as possible. Repeat with different notes, encouraging the student to locate them in various positions on the fretboard.

D. Variations
Increase the difficulty by using chords instead of single notes, requiring the student to find and play the entire chord. Time the student to see how quickly they can find and play each note or chord, encouraging them to beat their previous times. Incorporate intervals by having the student find and play two notes that are a specific interval apart.

E. Skill Level
Beginner to Advanced

10 - Bass Line Builder

A. Objective
To improve bass line creation and understanding of musical structure.

B. Needed to Play
Bass, a set of cards with different chord progressions or rhythmic patterns.

C. How to Play
Shuffle the cards and have the student draw one at random. The student must then create a bass line that fits the given chord progression or rhythmic pattern. Encourage the student to experiment with different rhythms, techniques, and styles.

D. Variations
Use more complex chord progressions or introduce specific styles (e.g., blues, funk, rock) that the student must incorporate into their bass line. Challenge the student to add embellishments like slides, hammer-ons, and pull-offs. Have the student play their bass line along with a backing track to practice playing in a band context.

E. Skill Level
Intermediate to Advanced.

11 - Rhythm Ruler

A. Objective
To enhance rhythm reading and playing accuracy.

B. Needed to Play
Fretted instrument, a set of cards with different rhythmic patterns, metronome.

C. How to Play
Show the student a card with a rhythmic/strumming pattern. Have them clap the rhythm first and then play it as either strumming patterns on the fretted instrument, or single notes on the bass/guitar. Use a metronome to maintain a steady beat.

D. Variations
Combine multiple rhythmic patterns to create a longer exercise. Increase the tempo gradually to challenge the student's accuracy and speed.

E. Skill Level
Beginner to Intermediate.

12 - Chord Tone Chase

A. Objective
To understand and play chord tones.

B. Needed to Play
Guitar/Bass, a set of cards with different chords (e.g., C major, A minor).

C. How to Play
Shuffle the cards and have the student draw one at random. The student must then play the chord tones (root, third, fifth, and seventh if applicable) on the guitar/bass.

D. Variations
Challenge the student to play the chord tones in different positions on the fretboard. Introduce more complex chords such as seventh chords.

E. Skill Level
Intermediate to Advanced.

13 - Improvisation Inspiration

A. Objective
To develop improvisation skills and creativity.

B. Needed to Play
Bass, a set of cards with chord progressions or modal scales.

C. How to Play
Shuffle the cards and have the student draw one at random. The student must then improvise a bass line or solo over the given chord progression or scale.

D. Variations
Use backing tracks to provide a harmonic and rhythmic context for the improvisation. Challenge the student to use specific techniques such as slides, hammer-ons, and pull-offs in their improvisation.

E. Skill Level
Intermediate to Advanced.

14 - Rhythm Relay

A. Objective
To enhance rhythmic accuracy and timing.

B. Needed to Play
Fretted instrument, metronome.

C. How to Play
The teacher claps or taps a rhythm pattern, and the student repeats it using a single note/chord. The teacher will then either add another one onto the first one (making it longer), or will start a new rhythm right away. Gradually increase the complexity of the rhythms.

D. Variations
Use different note values and rests in the rhythms. Have the student play the rhythms with different techniques, such as fingerstyle, slap bass, or picking.

E. Skill Level
Beginner to Intermediate.

15 - Finger Independence Drill

A. Objective
To enhance finger strength and independence.

B. Needed to Play
Fretted instrument.

C. How to Play
Create a series of finger exercises for the student to practice, such as playing one-finger-per-fret exercises up and down the neck. Focus on clean, even playing with all four fingers.

D. Variations
Incorporate different patterns, such as string skipping or alternating fingers. Use a metronome to gradually increase the speed of the exercises.

E. Skill Level
Beginner to Intermediate.

16 - Slap and Pop Challenge

A. Objective
To improve slap bass technique and rhythmic accuracy.

B. Needed to Play
Bass, a set of cards with different slap and pop patterns or exercises written on them.

C. How to Play
Shuffle the cards and have the student draw one at random. The student must then play the slap and pop pattern accurately on their bass. Focus on clean execution and maintaining a steady rhythm.

D. Variations
Include patterns of varying complexity, combining slaps, pops, hammer-ons, and pull-offs. Challenge the student to create their own slap and pop patterns and perform them. Use a metronome to gradually increase the speed of the exercises.

E. Skill Level
Intermediate to Advanced.

Chapter 5
Piano Games

1 - Pedal Pathway

A. Objective
To improve the use and control of the piano pedals.

B. Needed to Play
Piano with pedals.

C. How to Play
Create a simple piece or use an existing one. Have the student practice using the sustain pedal at the appropriate times. Gradually introduce the soft pedal and sostenuto pedal.

D. Variations
Use different pieces that require various pedaling techniques. Challenge the student to play a piece without using the pedal, then with the pedal, to understand its effect.

E. Skill Level
Intermediate.

2 - Chord Progression Puzzle

A. Objective
To enhance understanding of chord progressions and harmony.

B. Needed to Play
Piano, cards with different chords written on them.

C. How to Play
Shuffle the chord cards and lay them out. The student draws cards to create a chord progression and then plays it on the piano. Discuss the harmonic relationship between the chords.

D. Variations
Use specific types of chords (e.g., major, minor, seventh). Challenge the student to create progressions in different keys.

E. Skill Level
Intermediate to Advanced.

3 - Dynamic Duet

A. Objective
To improve dynamic control and expression.

B. Needed to Play
Piano, sheet music for a duet.

C. How to Play
Play a duet with the student, focusing on dynamic contrasts. Emphasize playing softly, loudly, and with gradual changes in volume.

D. Variations
Swap parts with the student. Incorporate different dynamic markings in the sheet music for added complexity.

E. Skill Level
Beginner to Intermediate.

4 - Melodic Maze

A. Objective
To develop melodic improvisation skills.

B. Needed to Play
Piano.

C. How to Play
Play a short melody and have the student try to replicate it by ear. Start with simple melodies and increase the complexity as they improve.

D. Variations
Use familiar songs or create melodies based on the student's favorite tunes. Challenge the student with melodies that include more complex rhythms or harmonies.

E. Skill Level
Intermediate to Advanced.

5 - Interval Identification

A. Objective
To enhance chord recognition and playing.

B. Needed to Play
Piano.

C. How to Play
Call out different chords (e.g., C major, G minor) and have the student find and play them on the piano. You can add variations by including inversions or extended chords.

D. Variations
Use chord progressions instead of single chords. Incorporate ear training by playing a chord and having the student identify it by ear before playing it on the piano.

E. Skill Level
Beginner to Intermediate.

6 - Rhythm Reversal

A. Objective
To enhance rhythm reading and performance.

B. Needed to Play
Piano, sheet music with rhythmic patterns.

C. How to Play
The teacher plays a rhythm and the student has to play it back on the piano, either clapping it first or playing it on a single note.

D. Variations
Use more complex rhythmic patterns, or use degrees of particular scales. Have the student play the rhythm with both hands in unison or alternating hands.

E. Skill Level
Beginner to Intermediate.

7 - Scale Switcheroo

A. Objective
To improve scale knowledge and dexterity.

B. Needed to Play
Piano.

C. How to Play
Call out a scale (e.g., C major) and have the student play it. After a few scales, switch to calling out different types (e.g., harmonic minor, pentatonic).

D. Variations
Increase the tempo or ask the student to play scales in contrary motion. Challenge the student to play scales with different articulations (e.g., staccato, legato).

E. Skill Level
Beginner to Intermediate.

8 - Piano Puzzles

A. Objective
To develop a sense of tempo and adaptability.

B. Needed to Play
Piano, cut-up pieces of simple sheet music.

C. How to Play
Cut a simple piece of sheet music into several sections. Mix up the pieces and have the student put them back in the correct order by listening and playing the segments. They can use their knowledge of musical structure and ear training to piece it together.

D. Variations
Increase difficulty by using more complex pieces or pieces in different keys. Alternatively, provide pieces with missing bars that the student must fill in by ear.

E. Skill Level
Bla bla

9 - Musical Storytelling Improv

A. Objective
To encourage creativity and musical expression.

B. Needed to Play
Piano.

C. How to Play
Tell the student a simple story or scenario (e.g., a sunny day in the park, a stormy night). Have the student improvise a piece of music that represents the story, using different dynamics, tempos, and musical elements to convey the mood and actions.

D. Variations
Give the student more complex stories or emotional scenarios to depict through music. You can also have them create their own stories and compose music to match.

E. Skill Level
Bla bla

10 - Musical Dice Game

A. Objective
To develop composition skills and creativity.

B. Needed to Play
Piano, dice, sheet music paper, a list of musical elements (e.g., chords, rhythms, dynamics) corresponding to dice numbers.

C. How to Play
Create a list of musical elements (chords, rhythms, dynamics, etc.) and assign each element to a number from 1 to 6. The student rolls the dice to randomly select elements for their composition. For example, if they roll a 3, they might choose the third chord from the list, the third rhythm pattern, and the third dynamic marking. The student then uses these elements to compose a short piece on the piano.

D. Variations
Use two dice to expand the range of options, creating a more complex list of elements from 2 to 12. Incorporate additional musical elements such as articulations, key signatures, or time signatures. Encourage the student to write down their composition and perform it, or even to create a story that goes along with the music.

E. Skill Level
Bla bla

Chapter 6
Vocal Games

1 - Vowel Variation

A. Objective
To improve vowel shaping and clarity in singing.

B. Needed to Play
List of vocal exercises or songs.

C. How to Play
Have the student sing a phrase or vocal exercise using different vowel sounds (e.g., "ah," "ay," "ee," "i," "oh," "oo,"). Focus on maintaining consistent pitch and tone quality.

D. Variations
Use words from a song and emphasize each vowel. Challenge the student with different dynamics while maintaining vowel clarity.

E. Skill Level
Beginner to Intermediate.

2 - Pitch Perfect

A. Objective
To improve pitch accuracy and ear training.

B. Needed to Play
Piano or pitch pipe.

C. How to Play
Play a note on the piano and have the student match the pitch with their voice. Gradually increase the range and difficulty by adding intervals.

D. Variations
Use a blindfold to eliminate visual cues, or have the student identify and sing intervals from a random starting pitch.

E. Skill Level
Beginner to Intermediate.

3 - Lyrics Scramble

A. Objective
To enhance memory and diction.

B. Needed to Play
Lyrics to a song written on separate cards.

C. How to Play
Write each line of a song's lyrics on a separate card and mix them up. Have the student arrange the cards in the correct order and then sing the song.

D. Variations
Use more complex songs as the student improves. Challenge the student to sing the song with different emotions or dynamics.

E. Skill Level
Intermediate to Advanced.

4 - Breath Control Challenge

A. Objective
To improve breath control and support.

B. Needed to Play
Voice.

C. How to Play
Have the student take a deep breath and sustain a note or phrase for as long as possible while maintaining consistent tone and pitch.

D. Variations
Use different dynamic levels and gradually increase the length of the phrases. Practice breathing exercises before singing.

E. Skill Level
Beginner to Intermediate.

5 - Emotion Explorer

A. Objective
To develop expressive singing and emotional connection.

B. Needed to Play
List of emotions and a song.

C. How to Play
Have the student sing a song while expressing different emotions (e.g., happy, sad, angry). Focus on how their tone, dynamics, and facial expressions change with each emotion.

D. Variations
Use a mirror so the student can observe their facial expressions. Have the student create their own emotional interpretations for a song.

E. Skill Level
Intermediate to Advanced.

6 - Interval Hunt

A. Objective
To improve interval recognition and vocal agility.

B. Needed to Play
Piano or pitch pipe.

C. How to Play
Play two notes on the piano and have the student sing the interval. Gradually increase the complexity by adding larger intervals and different directions (ascending and descending).

D. Variations
Sing intervals within the context of a song. Challenge the student with rapid interval changes.

E. Skill Level
Intermediate to Advanced.

7 - Tongue Twister Tunes

A. Objective
To enhance diction and articulation.

B. Needed to Play
List of tongue twisters.

C. How to Play
Have the student recite tongue twisters slowly, then gradually speed up while maintaining clarity. Transition to singing the tongue twisters on a simple melody.

D. Variations
Use different rhythmic patterns and tempos. Incorporate tongue twisters into actual song lyrics for practice.

E. Skill Level
Beginner to Intermediate.

8 - Harmony Hunt

A. Objective
To develop harmony singing skills.

B. Needed to Play
Piano or recorded harmony tracks.

C. How to Play
Sing a melody and have the student find and sing a harmony part. Start with simple intervals (thirds, fifths) and progress to more complex harmonies.

D. Variations
Use popular songs with well-known harmonies. Challenge the student to create their own harmony lines.

E. Skill Level
Intermediate to Advanced.

9 - Range Rover

A. Objective
To expand vocal range.

B. Needed to Play
Piano or pitch pipe.

C. How to Play
Warm up with simple vocal exercises, then gradually extend the student's range by singing scales or arpeggios higher and lower.

D. Variations
Use different vowel sounds and dynamics to explore range. Have the student sing parts of songs that challenge their range.

E. Skill Level
Beginner to Intermediate.

10 - Dynamic Duo

A. Objective
To improve dynamic control and expressive singing.

B. Needed to Play
Piano or recorded accompaniment.

C. How to Play
Choose a song and focus on singing it with various dynamic levels (e.g., pianissimo to fortissimo). Discuss and practice how dynamics affect the emotional impact of the song.

D. Variations
Use a decibel meter app to visualize dynamic changes. Incorporate crescendo and diminuendo exercises within the song.

E. Skill Level
Intermediate to Advanced.

Chapter 7
Orchestral String Games

1 - Bow Control Challenge

A. Objective
To improve bowing technique and control.

B. Needed to Play
Orchestral string instrument, bow, rosin.

C. How to Play
Have the student play long, sustained notes on open strings, focusing on smooth bow changes and even tone. Gradually increase the tempo and introduce different bowing techniques such as staccato and spiccato.

D. Variations
Use scales or simple pieces to practice different bowing styles. Incorporate dynamics and articulation into the exercises.

E. Skill Level
Beginner to Intermediate.

2 - String Crossing Race

A. Objective
To enhance string crossing skills and coordination.

B. Needed to Play
Orchestral string instrument, sheet music with exercises that involve frequent string crossings.

C. How to Play
Create a series of exercises that require the student to cross strings rapidly and accurately. Time the student to see how quickly and cleanly they can perform the exercises.

D. Variations
Use pieces that involve more complex string crossings. Incorporate slurs and different bowing patterns.

E. Skill Level
Intermediate to Advanced.

3 - Fingerboard Explorer

A. Objective
To improve finger placement and intonation.

B. Needed to Play
Orchestral string instrument, tape or stickers for fingerboard marking.

C. How to Play
Place stickers or tape at specific positions on the fingerboard. Have the student play scales or pieces while focusing on accurate finger placement.

D. Variations
Remove the markers and challenge the student to play by ear. Use different scales and positions on the fingerboard.

E. Skill Level
Beginner to Intermediate.

4 - Pitch Detective

A. Objective
To enhance pitch recognition and intonation.

B. Needed to Play
Orchestral string instrument, tuner or pitch pipe.

C. How to Play
Play a note on the tuner or pitch pipe and have the student match it on their violin. Gradually increase the difficulty by introducing intervals and melodies.

D. Variations
Use a drone pitch as a reference while playing scales or pieces. Challenge the student with harmonic double stops.

E. Skill Level
Beginner to Intermediate.

5 - Vibrato Voyage

A. Objective
To develop vibrato technique.

B. Needed to Play
Orchestral string instrument.

C. How to Play
Start with slow, exaggerated vibrato motions and gradually increase the speed. Have the student practice vibrato on different notes and strings.

D. Variations
Use pieces that require vibrato and focus on incorporating it smoothly into the music. Experiment with different vibrato speeds and widths.

E. Skill Level
Intermediate to Advanced.

6 - Rhythm Riddle

A. Objective
To improve rhythm reading and execution.

B. Needed to Play
Orchestral string instrument, sheet music with various rhythmic patterns.

C. How to Play
Provide the student with sheet music containing different rhythmic patterns. Have them clap the rhythms first and then play them on their instrument.

D. Variations
Incorporate complex rhythms and syncopation. Use a metronome to maintain a steady tempo.

E. Skill Level
Beginner to Intermediate

7 - Dynamic Duel

A. Objective
To enhance dynamic control and expression.

B. Needed to Play
Orchestral string instrument, sheet music.

C. How to Play
Choose a piece of music and focus on playing with various dynamic levels (e.g., pianissimo to fortissimo). Discuss and practice the impact of dynamics on the emotional expression of the piece.

D. Variations
Use a decibel meter app to visualize dynamic changes. Incorporate crescendo and diminuendo exercises within the piece.

E. Skill Level
Intermediate to Advanced.

8 - Articulation Adventure

A. Objective
To improve articulation and phrasing.

B. Needed to Play
Orchestral string instrument, sheet music.

C. How to Play
Choose a piece of music and focus on playing with different articulations (e.g., staccato, legato, accents). Discuss and practice the importance of phrasing in music.

D. Variations
Use different pieces to highlight various articulations. Challenge the student to create their own articulations for a familiar piece.

E. Skill Level
Beginner to Intermediate.

9 - Harmonic Hunt

A. Objective
To develop harmonic technique and ear training.

B. Needed to Play
Orchestral string instrument, sheet music with harmonics.

C. How to Play
Have the student find and play natural and artificial harmonics on the instrument. Focus on clean intonation and proper finger placement.

D. Variations
Use pieces or scales that incorporate harmonics. Challenge the student to create their own harmonic exercises.

E. Skill Level
Intermediate to Advanced.

10 - Scale Safari

A. Objective
To improve scale knowledge and finger dexterity.

B. Needed to Play
Orchestral string instrument, scale book or sheet music.

C. How to Play
Assign different scales for the student to practice. Focus on even finger placement, smooth shifts, and consistent bowing.

D. Variations
Use different rhythms and bowing patterns. Challenge the student with scales in double stops or three-octave scales.

E. Skill Level
Beginner to Advanced.

Chapter 8
Drum Games

1 - Drum Fill Frenzy

A. Objective
To improve creativity and timing with drum fills.

B. Needed to Play
Drum set.

C. How to Play
Have the student play a basic groove for a few measures, then create a drum fill for one measure. Alternate between the groove and the fill.

D. Variations
Use different tempos and styles of grooves. Challenge the student to use specific rudiments in their fills.

E. Skill Level
Beginner to Intermediate.

2 - Beat Matching

A. Objective
To enhance listening skills and groove replication.

B. Needed to Play
Drum set, possible music player.

C. How to Play
Play a recording of a song (or an instructor can form a beat) and have the student replicate the drum beat. Focus on matching the rhythm, dynamics, and style.

D. Variations
Use songs from different genres to expose the student to various drumming styles. Start with simple beats and progress to more complex ones.

E. Skill Level
Beginner to Intermediate.

3 - Polyrhythm Puzzle

A. Objective
To develop understanding and execution of polyrhythms.

B. Needed to Play
Drum set.

C. How to Play
Teach the student a simple polyrhythm (e.g., 3 against 2). Have them practice each part separately before combining them.

D. Variations
Introduce more complex polyrhythms as the student improves. Challenge the student to create their own polyrhythms.

E. Skill Level
Intermediate to Advanced.

4 - Tempo Change Challenge

A. Objective
To improve tempo control and adaptability.

B. Needed to Play
Drum set, metronome.

C. How to Play
Have the student play a groove at a steady tempo with the metronome. Periodically change the tempo and have the student adjust their playing accordingly.

D. Variations
Use sudden tempo changes to test the student's adaptability. Incorporate both slow and fast tempos.

E. Skill Level
Beginner to Intermediate.

5 - Accent Adventure

A. Objective
To enhance dynamic control and accent placement.

B. Needed to Play
Drum set, drumsticks.

C. How to Play
Provide the student with a series of rhythmic patterns and have them play while emphasizing different accents.

D. Variations
Use different parts of the drum set for accents. Challenge the student to create their own rhythmic patterns with specific accents.

E. Skill Level
Beginner to Intermediate.

6 - Groove Builder

A. Objective
To improve groove creation and timing.

B. Needed to Play
Drum set.

C. How to Play
Have the student start with a basic beat and gradually add elements (e.g., hi-hat variations, snare ghost notes) to build a more complex groove.

D. Variations
Use different time signatures and styles. Challenge the student to create grooves for specific genres.

E. Skill Level
Beginner to Intermediate.

7 - Hand-Foot Coordination

A. Objective
To develop coordination between hands and feet.

B. Needed to Play
Drum set.

C. How to Play
Create exercises that require independent movement of hands and feet, such as playing a steady hi-hat pattern while alternating between bass drum and snare.

D. Variations
Increase the complexity of the patterns. Use different rhythms and subdivisions. Double bass drum patterns can also be added.

E. Skill Level
Beginner to Advanced.

8 - Dynamic Drumming

A. Objective
To improve control over dynamics.

B. Needed to Play
Drum set.

C. How to Play
Have the student play a groove or fill at different dynamic levels, from very soft to very loud.

D. Variations
Use a decibel meter app to visualize dynamic changes. Incorporate crescendos and decrescendos within the groove or fill.

E. Skill Level
Beginner to Intermediate.

9 - Rudiment Relay

A. Objective
To enhance rudiment execution and speed.

B. Needed to Play
Drum set/Drum pad, drumsticks.

C. How to Play
Choose a series of rudiments for the student to practice. Start slowly and gradually increase the speed.

D. Variations
Combine rudiments into longer phrases. Challenge the student to use rudiments in their fills and solos.

E. Skill Level
Beginner to Advanced.

10 - Syncopation Station

A. Objective
To improve syncopation skills and rhythmic accuracy.

B. Needed to Play
Drum set, sheet music with syncopated rhythms.

C. How to Play
Provide the student with syncopated rhythmic patterns to practice. Start with clapping the rhythm, then play it on the drum set.

D. Variations
Use different parts of the drum set for the syncopated rhythms. Incorporate syncopation into grooves and fills.

E. Skill Level
Intermediate to Advanced.

About the Author

Daniel Jackson has more than 15 years of teaching lessons to musicians of all ages and levels of ability in groups, private lessons, or as a band. He has also developed curriculums to teach the finer points of learning drums, guitar, vocals, and other rhythm instruments.

After graduating from college in 2012, Daniel started training bands to learn their instruments and gel together groups when playing for the public. This led to a music career built by word-of-mouth, with Daniel getting similar opportunities to play, and train bands all across Canada.

Daniel was first drawn to music as a connection with his dad, but from the time he was 6 until the age of 16, he wanted to play the drums. He prayed for a chance to play when he was 16 and 2 weeks later, he got his first drumming opportunity.

Upon graduating high school, Daniel won the Music Spirit Award, plus played guitar and sang in front of the whole school. Between the ages of 16 and 21, he learned to play five instruments and sing.

Daniel is inspired by a student's interest in music truly coming alive, whether they are children or adult learners. He also believes a great aspect of music production is not just telling people what to do or where to put their fingers but developing a deeper learning of music that they can use in all areas of their lives. For Daniel, teaching is about having fun while learning proper techniques to make playing music easier and more enjoyable; to explore its emotions and understand the theory. He applies the same concepts to his personally-developed curriculum, which teaches music

teachers how to teach music, builds confidence in their students, and transforms musicians into leaders. He also credits his role as a pastor in his love for playing and teaching music.

For all other information, please visit our website at: www.revolutionmusicint.com

Giving Credit Where it is Due

I want to thank my Lord and Saviour, Jesus Christ, who helped guide me to where I am today, and helped me to understand music to the degree that I understand it. In 1999, when I was 16 years old, I asked God to teach me how to play music, starting with the drums. From there, I ended up learning how to play guitar, piano, percussion, bass, and how to sing. Now, I also teach these lessons, as well as teaching bands how to play.

I would also like to thank my wife, my child, my mother, father, stepfather, my uncle, and various friends and students who really supported me in my pursuits of music and of life. Each of them has played a significant role in getting me to where I am today.

Thirdly, I would like to thank my diffcrent college professors, high school teachers, and pastors of various churches who helped to guide me into a better understanding of music, and also helping me to develop my passion.

Testimonials

"I am happy to recommend Dan Jackson to anyone who is looking for a great music teacher. He is a very talented musician who brings thoughtful dedication to everything he does. Dan does a great job of breaking musical ideas into teachable chunks so that his students are able to understand it clearly and apply it to their own playing." - Jason

"I've been taking guitar lessons for two months now. As someone who is at a beginner level, I have found Dan to be very patient, kind and understanding. Thanks Dan!" - Penny

"Dan is simply the best! He is patient, helpful, kind, and makes you feel comfortable during your lessons. I'm very happy to have him for my Music Teacher. Thank you Dan for being so awesome. You get an A+ from me!" - Joan

"I have been very pleased with the method, as well as attitude that Daniel has provided us here at our church. Our youth have gained so much confidence and have gained so much needed knowledge of what music is. It has been a blessing to see what someone with a passion for music can do with our youth who were struggling to learn on their own, and have seen such a big improvement and can now, in turn, encourage the youth to press on." - Alex

"I would recommend Daniel! Great music instructor knows the ins and out of music. Great for helping you understand every part of playing an instrument" - Carter

"Dan is an amazing music educator! He is passionate and very patient. His teaching approach is practical and has great quality. He is generous in imparting his musical knowledge and experience. His curriculum is excellent and well thought of. He goes above and beyond my expectations. I absolutely recommend him!" - Teresa

"Dan is an excellent music teacher. He has helped me a great deal in my drumming over the years because of his extensive knowledge and experience when it comes to music. If you are looking for a practical, down to earth teacher, where you will see quick progress, look no further!" - Andrew

"He has really helped me and led me through my guitar career and has helped me amazingly in music. I completely felt at home when getting lessons with him and the learning was hard at first, but through perseverance and strength I became way better. And all thanks to the wonderful Dan the music man" - Roba

"Dan's teaching style is very unique and easy to understand the basic rudiments of music foundation. Dan is also very patient and kind. I'm taking bass guitar lessons and I was able to play chords from a simple worship song he picked for me to practice, just after few weeks of training. This is amazing!" - Maureen

"Dan is an exceptional musician who is also able to explain both basic and complex musical fundamentals at your level, whether you've been playing for decades, or have never picked up an instrument." - Jeremy

www.ingramcontent.com/pod-product-compliance
Lightning Source LLC
Chambersburg PA
CBHW071926210526
45479CB00002B/575